Sketching Street Scenes

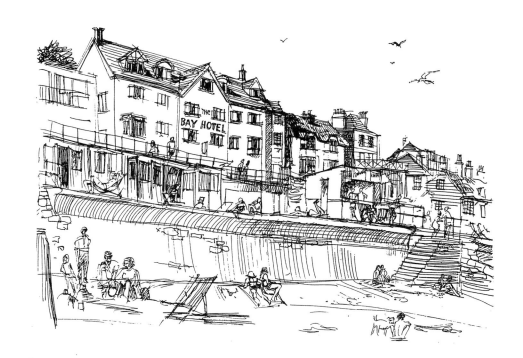

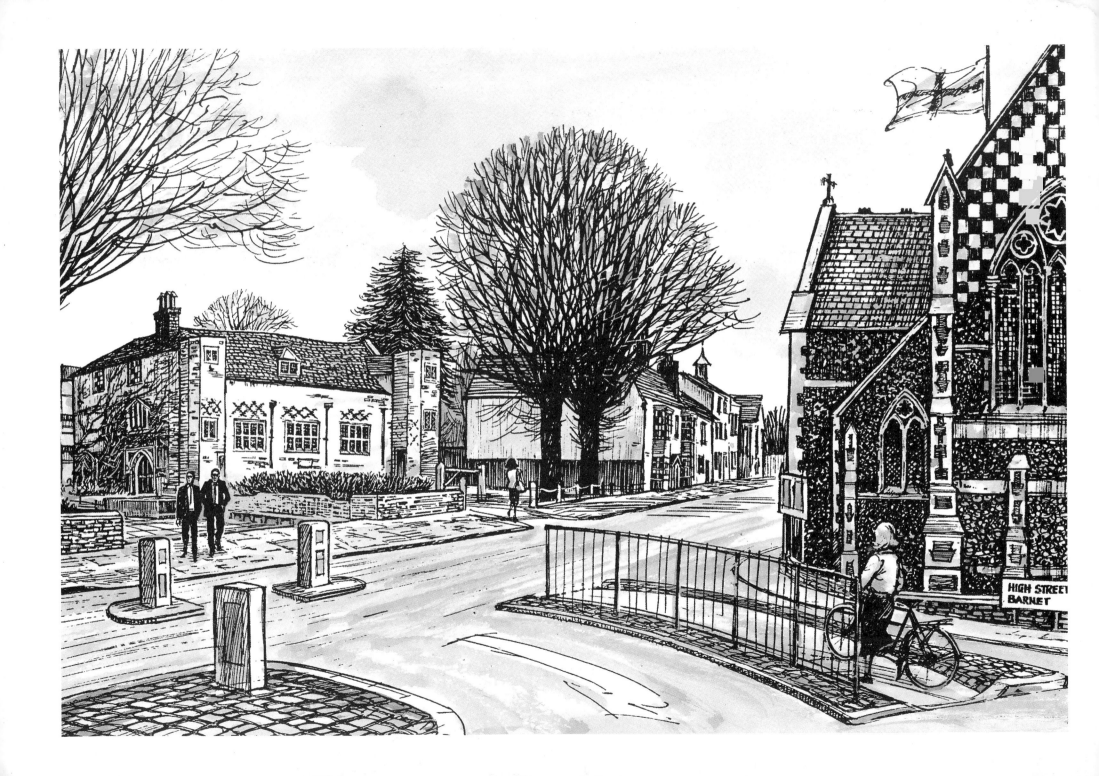

Sketching Street Scenes

JOHN MARSH

CASSELL

Cassell
Wellington House, 125 Strand
London WC2R 0BB
www.cassell.co.uk

Distributed in the United States by
Sterling Publishing Co. Inc.
387 Park Avenue South
New York NY 10016-8810

British Library Cataloguing-in-Publication Data
A catalogue record for this book is available from the British Library

ISBN 0-304-35164-4

Printed and bound in Great Britain by Hillman Printers (Frome) Ltd, Somerset

Contents

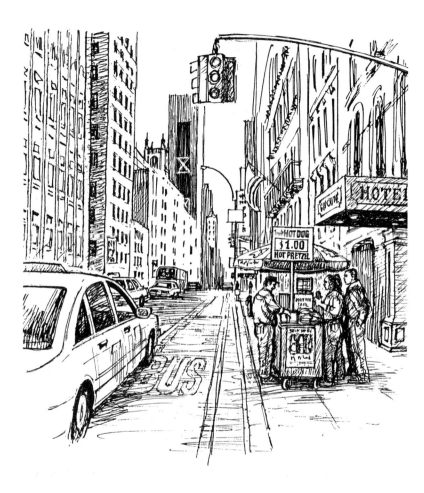

Sketchbooks

Without observation and experimentation no artist can expect their work to improve and this is why most serious students keep sketchbooks. Nowadays many traditional tools, skills and methods are in danger of being overlooked in the mistaken belief that new technology has made them somehow redundant. However, there can be no substitute for drawing.

Drawing should not be confused with trying to contrive photo-realistic representations. It is more about learning to 'see' than the mastery of mere technique. Through drawing, our visual senses become more finely tuned, and we are better able to liberate our imagination.

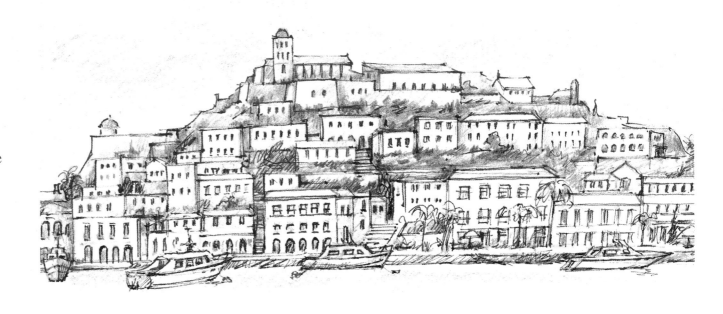

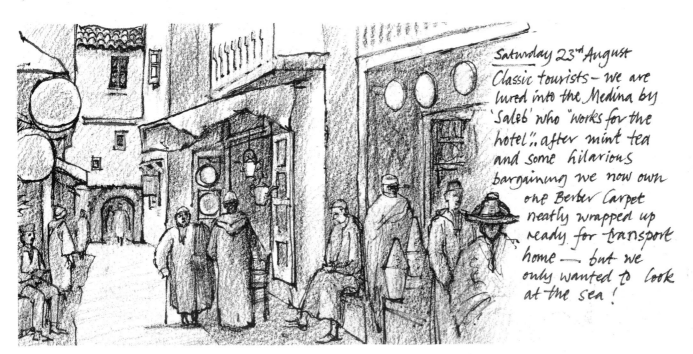

Saturday 23rd August
Classic tourists — we are lured into the Medina by 'Saleb' who "works for the hotel". after mint tea and some hilarious bargaining we now own one Berber Carpet neatly wrapped up ready for transport home — but we only wanted to look at the sea!

Keeping a sketchbook can be great fun and a good way of recording your discoveries and experiences. If you haven't already got one on the go, I would like to encourage you to begin straight away.

By definition, a sketch is something a little less than finished, and is first and foremost a personal activity. It has to be valued for what it conveys to the originator rather than being judged by formal artistic standards. It's rather like writing yourself a note in your own handwriting – it might be unintelligible to anyone else but it does what you intend it to do and that's all that matters. In the same way, a sketch can be a reflection of your personality, attitude and circumstances and a visual interpretation of your imagination.

Using examples from my sketchbooks I shall attempt to identify some of the difficulties and pleasures of sketching street scenes.

Some sketches are best done on the spot, but if you train your visual memory you can draw things later from your memory banks. The more you draw from observation and make notes, the better your visual recall will become.

My sketchbooks are often more like visual diaries. They combine drawings, maps, written notes, photos, collected tickets, cuttings, postcards, pressed flowers, colour samples. In short anything which can be stuck in a book as useful reference material.

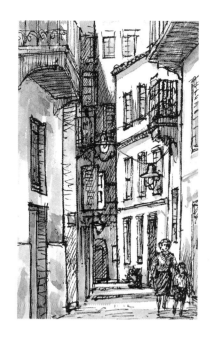

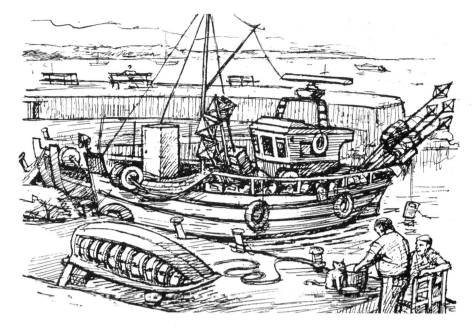

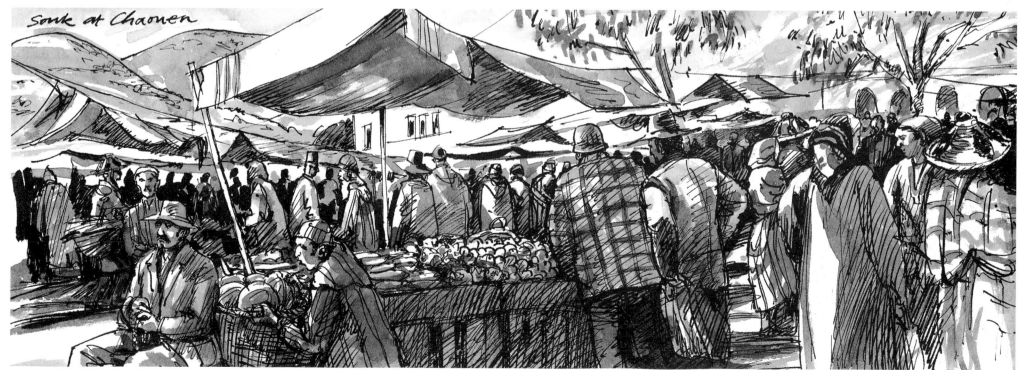

Souk at Chaouen

Sketching in towns

Here are a few of the special difficulties likely to be encountered at the outset, together with some suggestions to help overcome them.

A basic understanding of perspective is a key requirement when drawing buildings and structures. Also, the appropriate inclusion of people or human interest is highly desirable if the street scenes are not to look like the aftermath of some dreadful catastrophe. Both of these factors are dealt with in as much detail as space allows in later stages of this book.

On a more general level, it is much harder to work unobserved in towns than in the wide open spaces. Unless you possess outstanding self confidence or have an aspiration to become a performance artist, it is advisable not to set up an easel on a street corner; there are a number of alternatives which are fairly effective. Get your back up against something so that an audience can't form behind you. (I thought I had achieved this once by sitting against a sea wall only to hear a comment from a small crowd above me.) On the other hand, standing propped against a wall glancing up frequently and making marks in a small notebook can make one look suspiciously like a private detective or a villain planning a robbery.

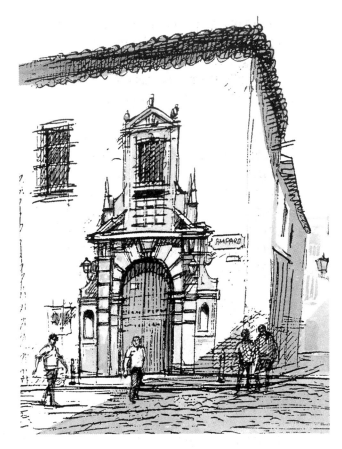

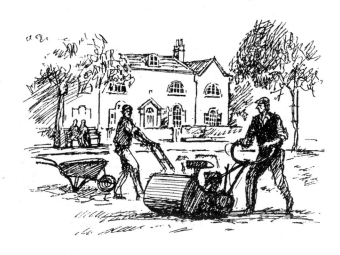

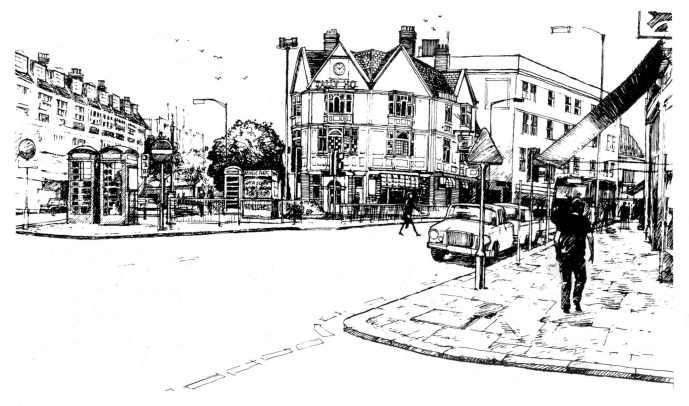

Once a group of council gardeners began working frantically as I drew them, in the mistaken belief that I was an official conducting a time and motion study. After I told them this was not the case they relaxed into more suitably recumbent poses.

It is much more comfortable and less conspicuous if you are able to sit down to make a sketch. Park benches are good except you can become a sitting target for every passer-by with time on their hands and problems to share; overhead pigeons may also want to join in the fun. A small inflatable cushion can make sitting on walls and steps a more attractive option.

The ultimate luxury is to draw from a cafe or a bar accompanied by an amiable companion and an appropriate beverage. Some of my most enjoyable memories are associated with this gentle activity, either outdoors in warm weather or captured through windows whilst sheltering from the elements.

If you avoid peak periods and look out for traffic wardens, a car can provide good vantage points, privacy and shelter and, in the case of my camper van, occasional refreshments.

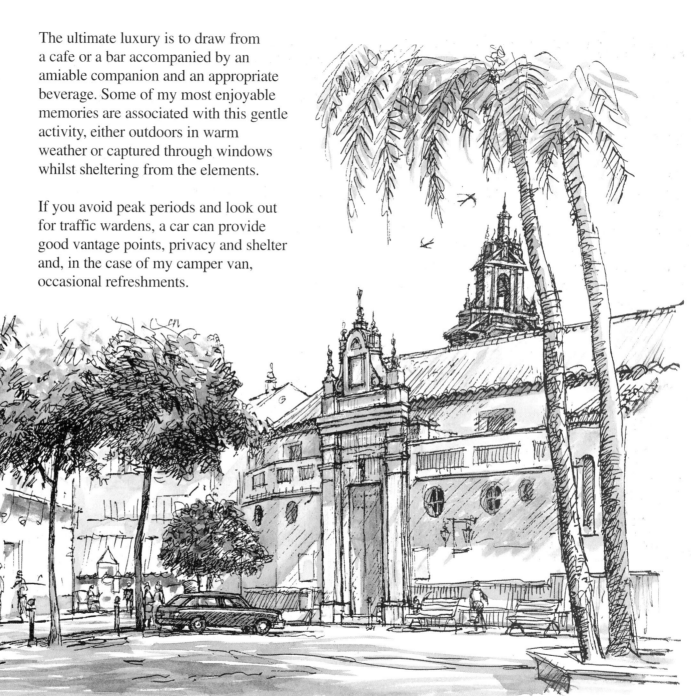

Gathering information

A commission from my local town council to produce a series of line drawings featuring places of local interest started me drawing street scenes. Without this challenge I would probably have stuck to country landscapes, but once I got started I found it very absorbing.

Unfortunately, when I know my work is going to be printed, I find it is harder to maintain the freedom and spontaneity which comes with drawing purely for pleasure. Drawing within imposed time limits means that I sometimes can't help producing some rather 'tight' drawings, such as the one on the right, an example of this rather more laborious and detailed approach.

Sketchbooks can be used for collecting visual information which may later be put together in more finished compositions. For example, studies of people, animals or small details. A camera is also handy if you run short of time.

Drawing directly with a pen without any preliminary pencil work forces you to sum up a situation in the simplest terms. If a line is wrong you have to 'overdraw' the first mark because it is impossible to rub out. This is a good way of developing your personal 'visual handwriting'.

Using a pen which you don't have to keep dipping into an ink bottle can assist in the speed of a drawing. For this reason, some artists use a fibre-tipped, a fountain or a ballpoint pen.

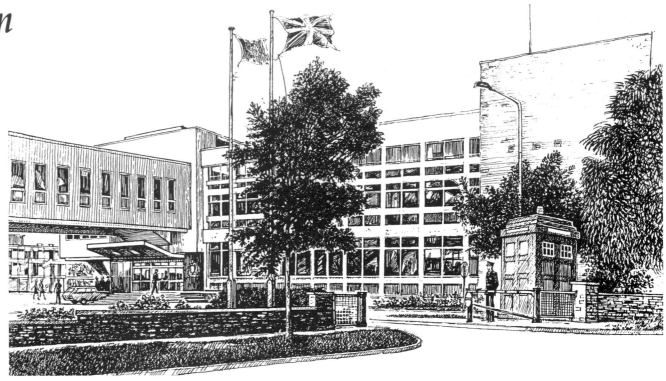

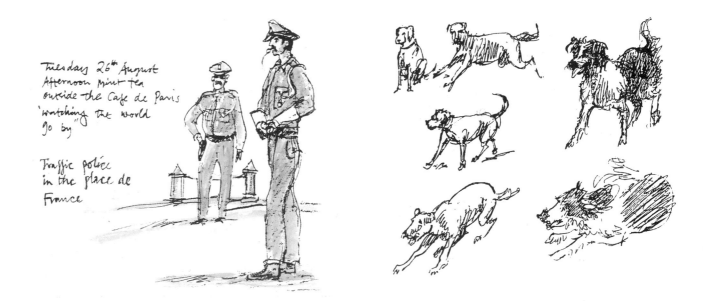

Tuesday 26th August
Afternoon mint tea
outside the Cafe de Paris
'watching the world
go by'

Traffic police
in the place de
France

Basic equipment

Sketching outdoors requires one to travel light, carrying only a small selection of tried and trusted tools and equipment which will fit into a pocket or a small bag. Use of simple and familiar tools, such as pencils or pens, is less conspicuous if working outdoors on location. To some extent your choice of these will influence your approach, direct what you look at and the information you are able to put down.

Pencils

For fine details, it is better to use well sharpened H grade pencils and smooth paper surfaces. For broad tonal impressions, try soft B grade pencils, charcoal, crayons or pastels and rough-surfaced papers.

You will need to keep sharpening soft pencils, so have a craft knife or sharpener with you. Kneadable erasers can be shaped to a point, enabling you to rub out, lighten or highlight specific areas. Use your fingers or specially made, rolled cardboard torchons to blend tones, and remember to spray your work with fixative so it doesn't smudge.

Water-soluble pencils combine the advantages of normal graphite with the capability of creating washes when wet. For this I carry water in a 35mm film cassette case and a small watercolour paintbrush.

HB graphite pencil on smooth cartridge paper.

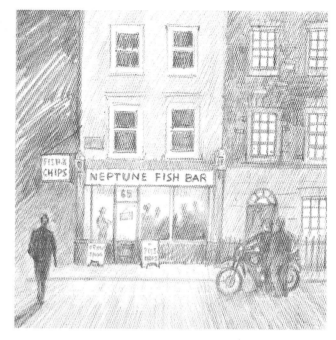

Soft and hard graphite pencils combined.

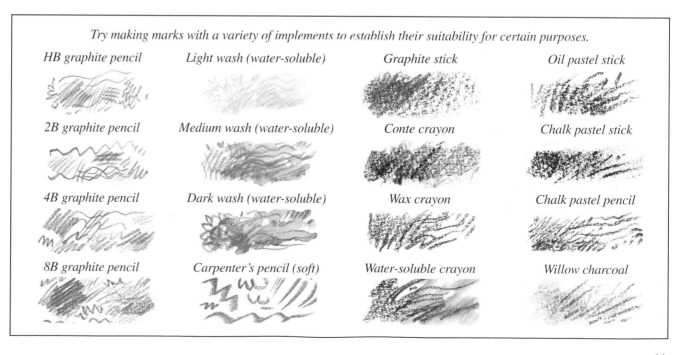

Try making marks with a variety of implements to establish their suitability for certain purposes.

HB graphite pencil	Light wash (water-soluble)	Graphite stick	Oil pastel stick
2B graphite pencil	Medium wash (water-soluble)	Conte crayon	Chalk pastel stick
4B graphite pencil	Dark wash (water-soluble)	Wax crayon	Chalk pastel pencil
8B graphite pencil	Carpenter's pencil (soft)	Water-soluble crayon	Willow charcoal

Pens and brushes

There should be no problem finding a pen and brush of your choice since there is a plethora of them in the shops. While they are cheap and portable, both of which are very handy, watch out for the occasional disadvantage – some fibre-tips will run if you put a wash over them; others have a tendency to bleed through one or more sheets of paper.

It is important to be able to create a contrast in line thickness if you want your drawings to have vitality, so consider using a range of instruments – rollerballs, brush pens, fine liners, technical and calligraphy pens.

'Dip' pens give a variety of marks. Use them with inks which are either 'fixed' or waterproof when dry, or 'unfixed' which are not. They have the advantage over other pens and brushes because they do not clog up.

You can cut, sharpen and customize reed pens, bamboo pens and quills.

Steel nibs, fitted into holders, come in various widths and their mark on paper is dictated by how hard you press.

To avoid fountain sketching pens clogging up, use them with unfixed ink.

Sable and synthetic hair brushes can be bought in many forms and sizes. A 'rigger', a brush with long hair used by nautical painters to draw in the fine lines of rigging, can be almost like a pencil to draw with.

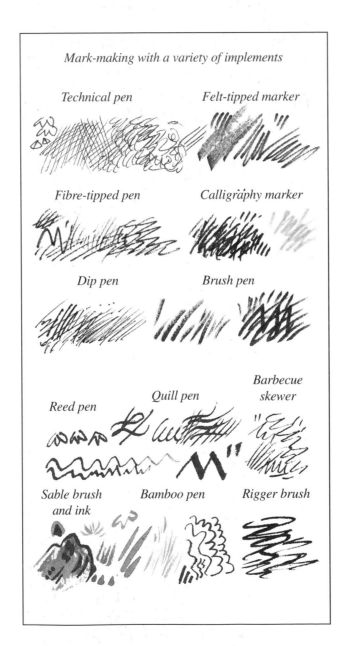

Mark-making with a variety of implements

Technical pen

Felt-tipped marker

Fibre-tipped pen

Calligraphy marker

Dip pen

Brush pen

Reed pen

Quill pen

Barbecue skewer

Sable brush and ink

Bamboo pen

Rigger brush

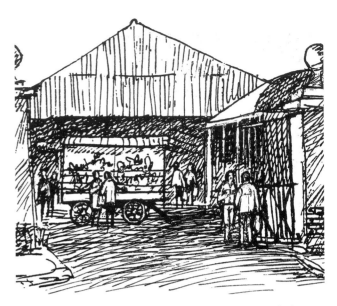

Pen sketch on smooth paper. Tones have to be made by crosshatched lines.

Line and wash sketch on watercolour paper. Begun with a water-resistant, fibre-tipped pen, the tonal ink washes were applied afterwards with a sable brush.

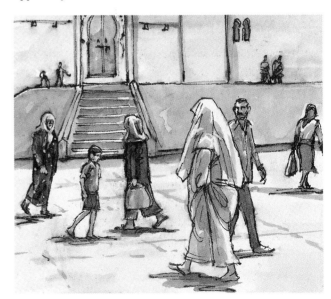

Types of paper

The choice of sketchbook should be influenced by its function. Size and weight are big factors to consider if you intend to carry it with you every day. Sturdy binding will be a big advantage if it is going to have to travel well. At the expensive end of the market are handmade and bound watercolour books; beautiful but perhaps a touch daunting. More practical are the low-cost cartridge pads. Even cheaper still are individual sheets of paper and a drawing board or clipboard.

Paper

In general there are three types of surface:
• smooth or 'hot pressed' (mechanically pressed through hot rollers) which is suitable for fine detail and pen work;
• semi-rough or 'not' pressed which will suit most purposes;
• rough and textured papers which suit broader treatments.

Paper has different thicknesses, or 'weights', and absorbencies, which make it either more or less suitable for wash treatments. Generally speaking, a watercolour sketchbook and heavier weight papers will cover most options. Cheaper lightweight papers must be 'stretched' on a drawing board so that they do not buckle when water is applied to them.

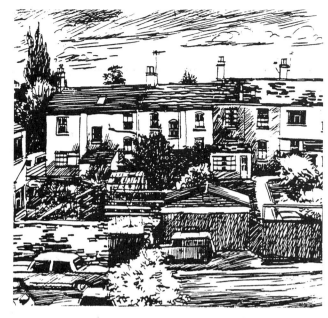

Pen sketch on smooth, 'hot pressed' paper. Ideal for quick line drawing in pen or harder grade pencils.

Pencil on inexpensive cartridge paper. The smooth surface is ideal for general drawing and detailed work.

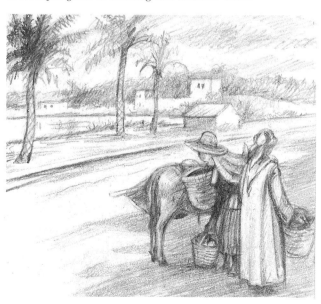

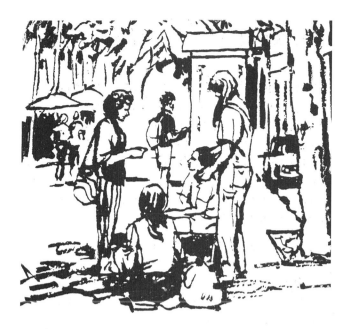

Brush drawing on semi-rough watercolour paper without preliminary pencil work.

Pen line and wash sketch on watercolour paper. A pen draws the linework first; loose washes are then applied.

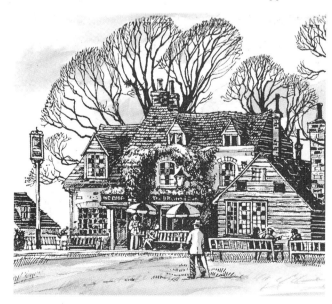

Locations and subjects

Everyday locations can become more interesting as you begin to draw them and it is not really necessary to go far in search of subject matter.

Somehow qualities seem to emerge as we get into looking closely and trying to represent honestly what we see. Time spent in looking before drawing is seldom wasted but it is important not to become paralysed with fear at the enormity of the task ahead of you.

Drawing shouldn't be a tedious activity; if you get bored just simplify or leave out things you don't find interesting. On the other hand, bring in other things you want to include or move them about to add to your composition.

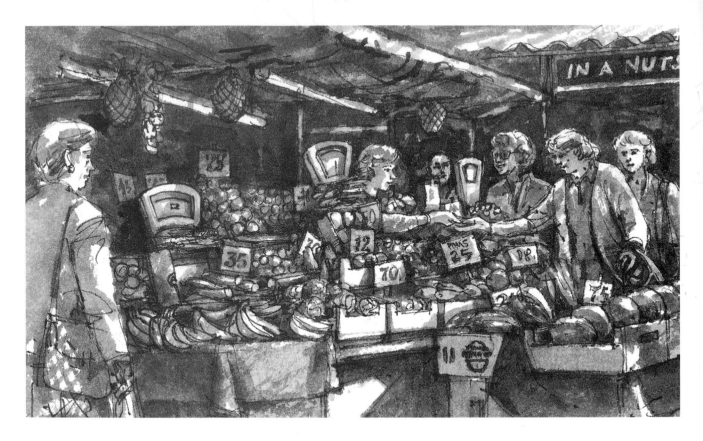

The landscape is in a constant state of change, especially in towns, where your drawings can become unique historical records of buildings or local characteristics which may be eliminated or modified by redevelopment schemes.

Make a list of some possible areas of interest which might yield promising subject matter or may in turn become themes for a whole series of drawings. Here are a few examples – pubs, street markets, car boot sales, back gardens, allotments, parks and sportsfields, cinemas, street entertainers, railway stations or sidings, bridges, cemeteries and monuments.

14

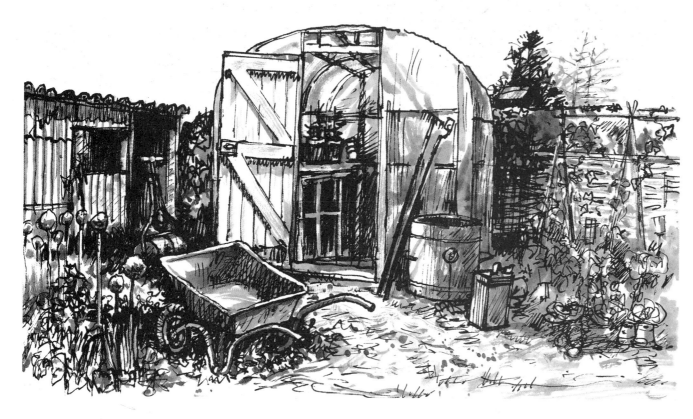

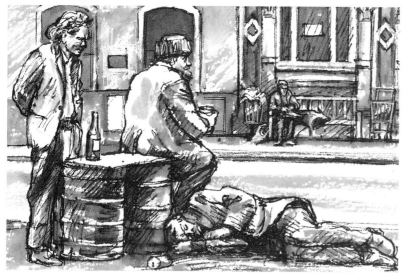

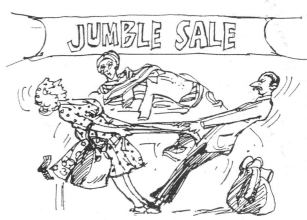

I SAW IT FIRST!

Basic shapes and components

Complex forms found in architecture can be confusing to draw so a suggestion is to see if they could be based on more simplified geometric shapes, rather like children's toy bricks. Try basing them on a framework of cubes, rectangles, cones or cylinders before adding any elaboration and surface details; this gives a better understanding of the way that light can fall on structures and make them look more three-dimensional. This approach can also be applied to other objects within the landscape such a motor cars, telephone kiosks and even trees.

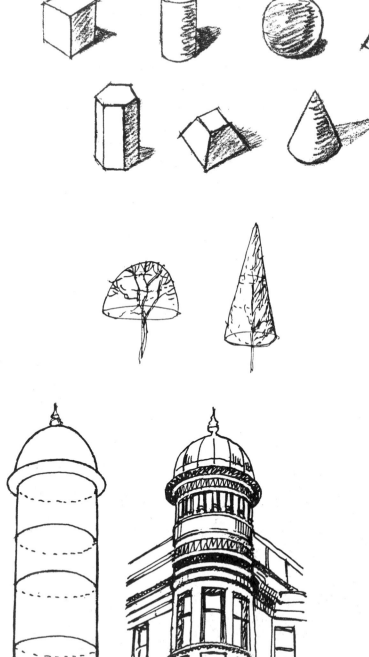

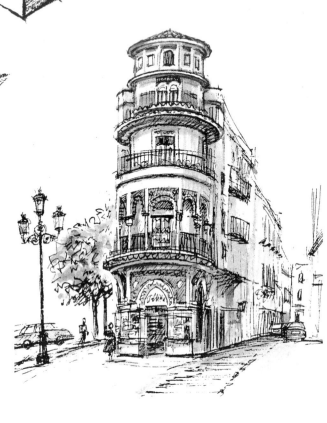

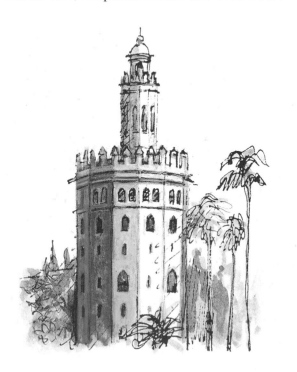

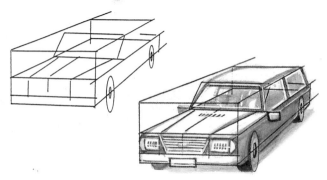

Perspective

Try not to be daunted as you start drawing by the knowledge that your sense of perspective could be better. It is something that will improve vastly if you follow these guidelines and you will soon find that you are able to make convincing visual representations of objects in space.

To create an illusion of depth and recession, there must be a contrast between foreground, middle ground and distance. A sketch can contain visual clues to give the viewer an idea of distance.

Items in the foreground are larger and more distinct; the further away they are, the fainter and less defined they become.

This is called 'atmospheric perspective'. Emphasize this difference with a distinct tonal contrast in foreground and background layers.

There are various other clues – overlapping areas, forms and contours, which define whether one thing is in front of another, and the intervals between similar sized elements such as windows, streetlamps or paving stones appearing to diminish in size as they recede in the distance.

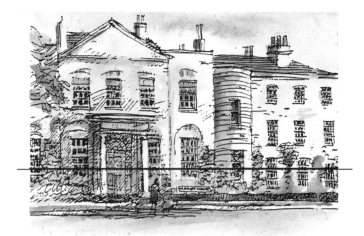

The horizon is easy to see when we look out to sea it is the line between the sea and the sky. However, it is less obvious with a landscape.

ATMOSPHERIC PERSPECTIVE

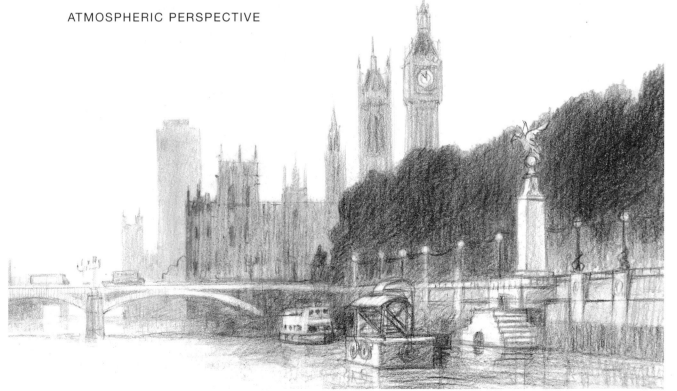

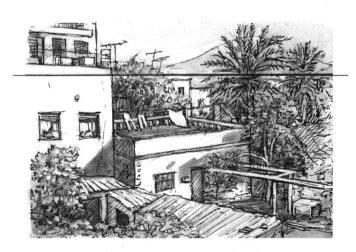

The position on the page of the horizon line creates a subdivision between the areas of land and sky. Dynamic compositions can be achieved by allowing one or the other to dominate, rather than making everything symmetrical.

The horizon can be raised or lowered on the page to reflect the focus of your interests. To attract the eye to the sky, make the horizon lower down on the page.

The same can be said if you want to look down on a scene.

To concentrate more on the foreground, have a higher horizon.

To keep everything in the sketch in perspective, all structures or elements in the landscape have to be drawn in relation to the established horizon.

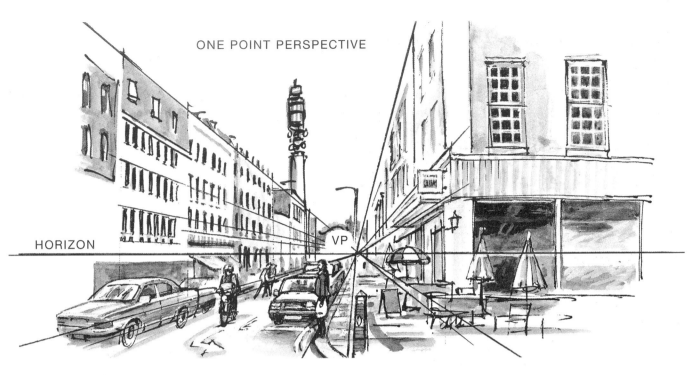

ONE POINT PERSPECTIVE

HORIZON VP

The general rule is that all receding parallel lines above your eye level appear to slant down towards the horizon while those below eye level travel upward. The point on which these converge is called the vanishing point (VP).

'**One point perspective**', as illustrated above, describes the situation observed when there may be only one obvious vanishing point.

An exercise that will help you with perspective is to lay tracing paper over a photograph of some buildings and, with a ruler, trace lines which seem to converge so that you can see where they intersect. This will indicate the camera level and the point at which the lens was focused when the photograph was taken.

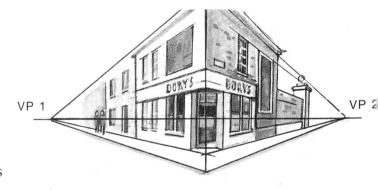

TWO POINT PERSPECTIVE

VP 1 VP 2

When looking at a building corner-on, with its sides receding away acutely on either side, there are two vanishing points, one to the left and the other to the right, as illustrated above. This is commonly known as '**two point perspective**'.

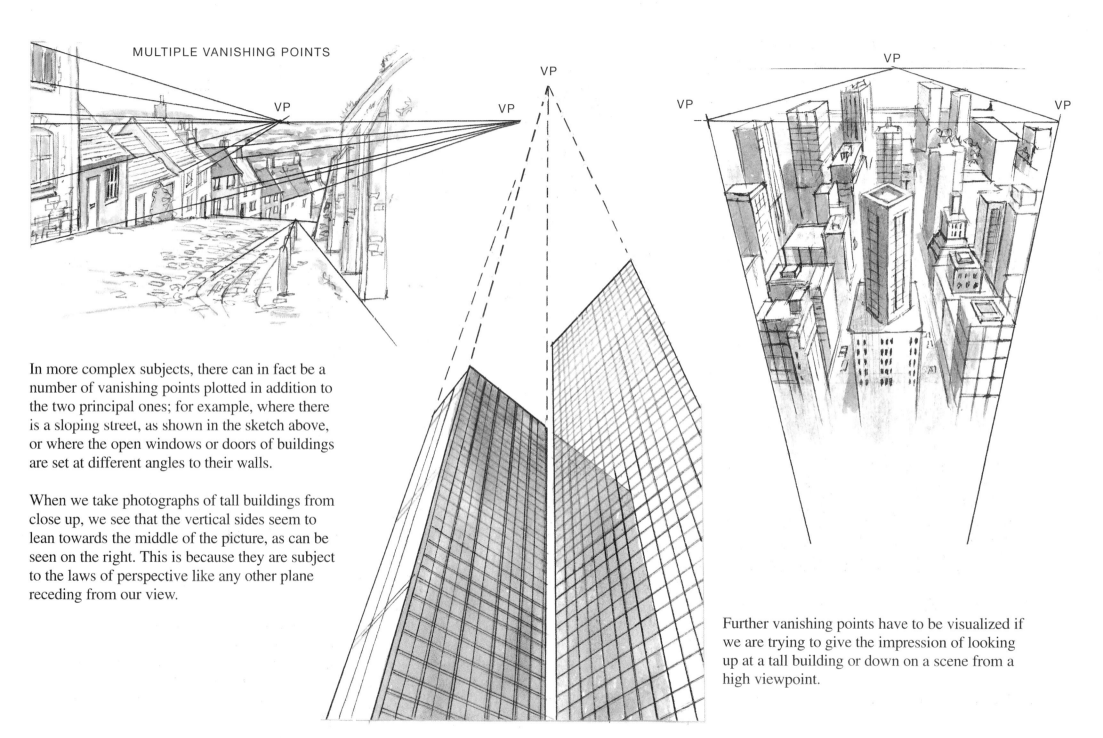

In more complex subjects, there can in fact be a number of vanishing points plotted in addition to the two principal ones; for example, where there is a sloping street, as shown in the sketch above, or where the open windows or doors of buildings are set at different angles to their walls.

When we take photographs of tall buildings from close up, we see that the vertical sides seem to lean towards the middle of the picture, as can be seen on the right. This is because they are subject to the laws of perspective like any other plane receding from our view.

Further vanishing points have to be visualized if we are trying to give the impression of looking up at a tall building or down on a scene from a high viewpoint.

19

Curves and ellipses

Fortunately the rules of perspective apply just as much to curves as to straight lines. If you are trying to draw arches, for example, there is a simple trick to assist in getting them right by fitting them first into rectangles, which can be drawn in perspective, and then establishing their centres by crossing diagonals as shown in the following diagrams.

The same device can be used for ellipses which can be fitted within squares drawn in perspective as shown.

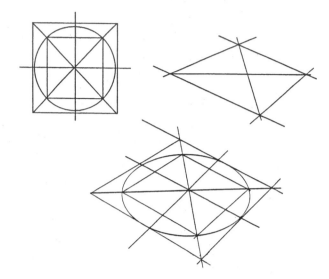

Diagram for plotting diminishing vertical intervals in perspective.

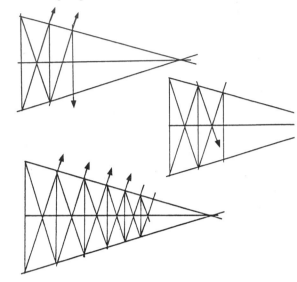

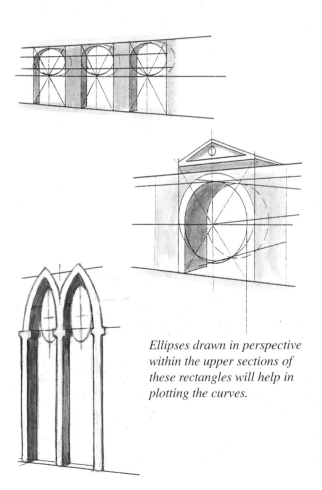

Ellipses drawn in perspective within the upper sections of these rectangles will help in plotting the curves.

Diagram for finding the intervals between receding paving stones, in one point perspective.

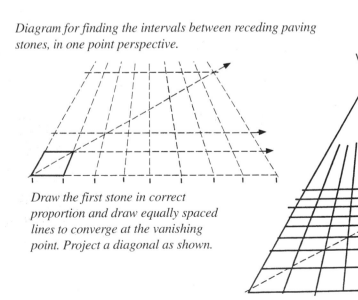

Draw the first stone in correct proportion and draw equally spaced lines to converge at the vanishing point. Project a diagonal as shown.

VP

Where this diagonal intersects the converging lines establishes the diminishing intervals. It is possible to apply this principle if the square is viewed with lines converging towards two vanishing points.

Tone, light and shade

The term 'form' describes the visual appearance and shape of something. Lines and 'tones' (a range of values from light to dark) are used to represent form on paper; the addition of more tones gives an impression of greater solidity. In the sketch of the bridge, below, look first at the simple line framework and then below that at the 'modelling' effect of strong sunlight throwing areas into shadow.

The techniques of 'modelling' using tones will vary according to the media used – soft tools such as pastel, charcoal, crayon or graphite will allow you to produce large areas of tonal shading. The top illustration was done with pen and diluted ink washes. Hard pen, however, as in the drawing of the bridge at the bottom of the page, means you can render tones by crosshatched lines or stippling.

Forms and textures are revealed to us by light, but this changes throughout the day and depends upon weather conditions. We often have to be very quick to capture the effect on paper.

Strong sunlight can give hard-edged shapes, while more diffused lighting will be soft and atmospheric. It is worth concentrating on the contrasts between light and dark; remember to indicate the big shapes first before getting involved in any detail.

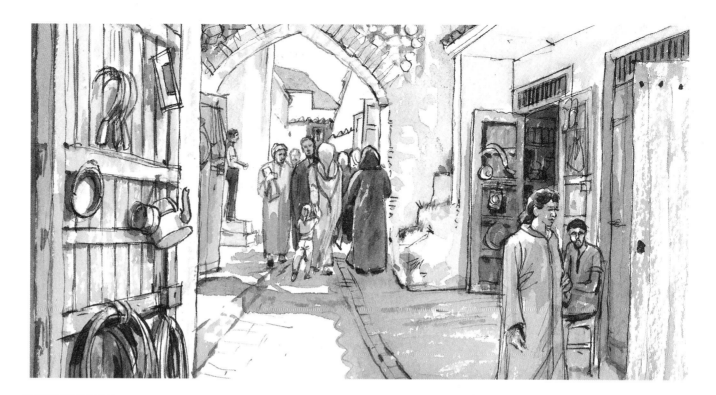

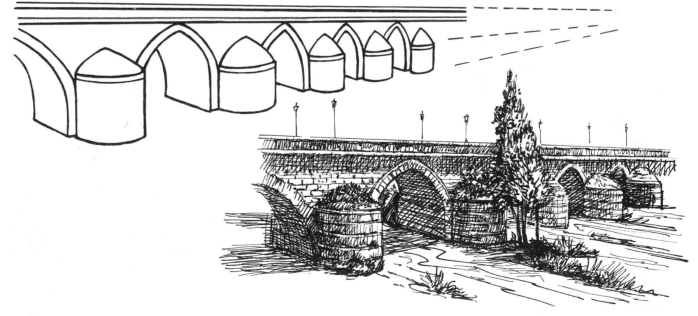

Sunlight and shadows

It is important to establish the location of light sources in relationship to your drawing in order to understand how or where shadows are cast. This is helpful especially in strong sunlight where they will be very pronounced. Perspective also comes into play, as shown here in these diagrams.

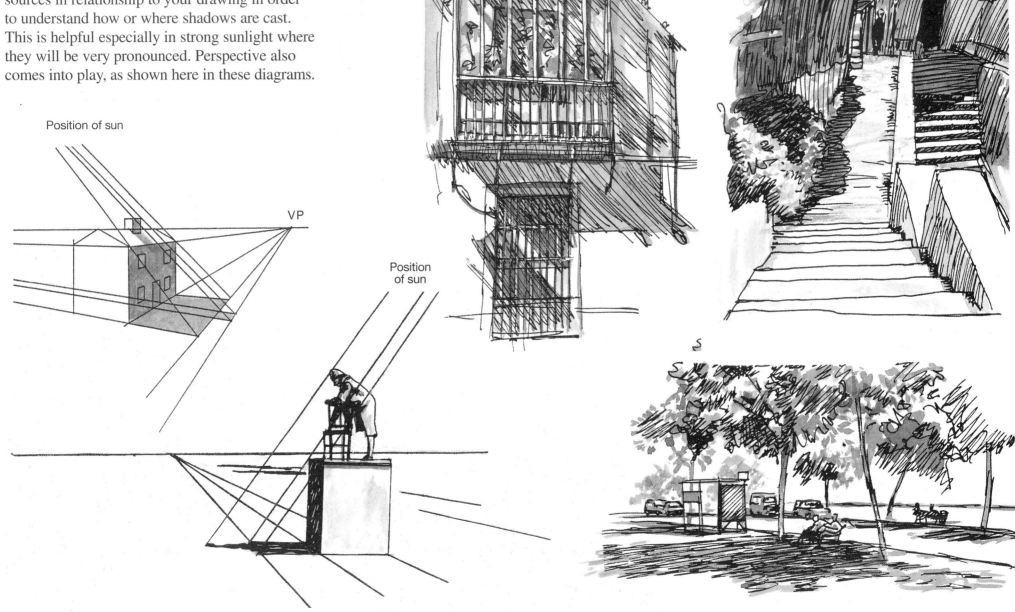

Position of sun

VP

Position of sun

Buildings and architecture

A knowledge of architecture is not necessary for sketching buildings but it will increase your enjoyment and understanding to find out something of the historic developments as you progress, and how the regional character of towns is frequently the result of the use of traditional local materials and architectural styles.

Modernization of buildings in towns and villages has often destroyed this regional charm and regrettably the concrete-box style seems to have spread almost unchecked. Of course not every redevelopment is negative and some have been notably interesting and sensitive.

In towns all the elements that go to create the environment – buildings, trees, water, advertisements, traffic and so on – are collectively woven together to produce a dramatic impact.

Some locations are more obviously inspirational than others and may have attracted painters and draughtsmen in the past. However, the challenge is to find your own situations and approaches. For instance you may be more interested in atmosphere – the play of light on buildings rather than the recording of architectural details.

Market towns as depicted in the watercolour sketch on the right are frequently rich in architectural styles.

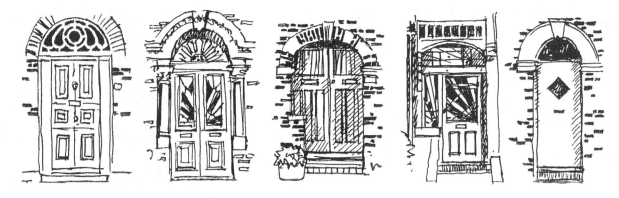

Studies of such common objects as front doors, above, can reveal surprising variations.

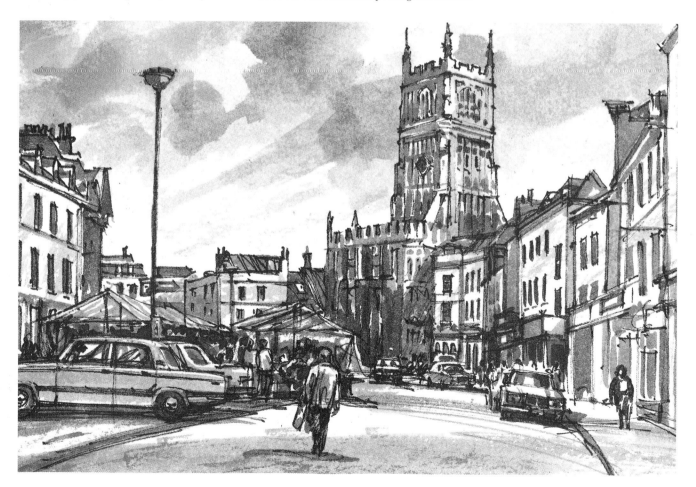

In contrast to more conventionally picturesque rural landscapes, street scenes can make dramatic and fascinating subjects teeming with interest.

It's a good idea to draw in the basic immovable components before adding figures and vehicles which come and go. The building site in the sketch below right was later to become a local shopping centre and an example of recording 'history in the making'.

Old buildings offer rich areas of exploration. There are usually opportunities to discover textures and small details which might be less obvious but more interesting to draw. Attempting to render surfaces with different media is quite rewarding.

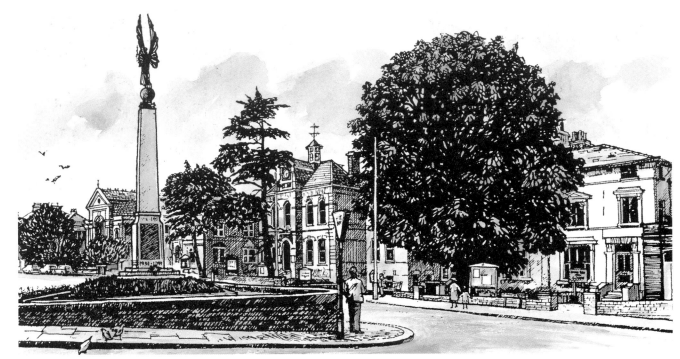

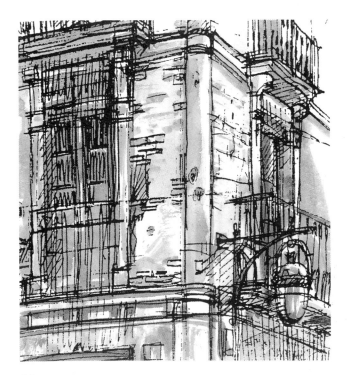

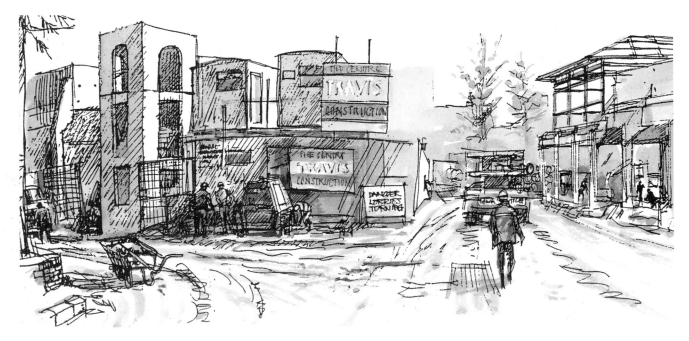

Landmarks and street furniture

Monuments, lamp-posts, pillarboxes, street signs, telephone boxes, benches, railings, bollards and a host of little unique details bring vitality, humanity and interest to our towns. They can become features worth studying in their own right or be included in pictorial compositions.

On the other hand, it sometimes assists a drawing to leave out clusters of traffic lights and signage when they would become an intrusion. We can have more control over the image in a drawing than would be possible with a photograph.

A mixture of the old and new can frequently be found in certain districts. For example, the water gate in a London park, illustrated on the right, is well over 300 years old.

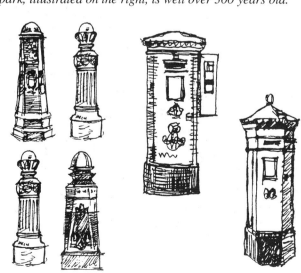

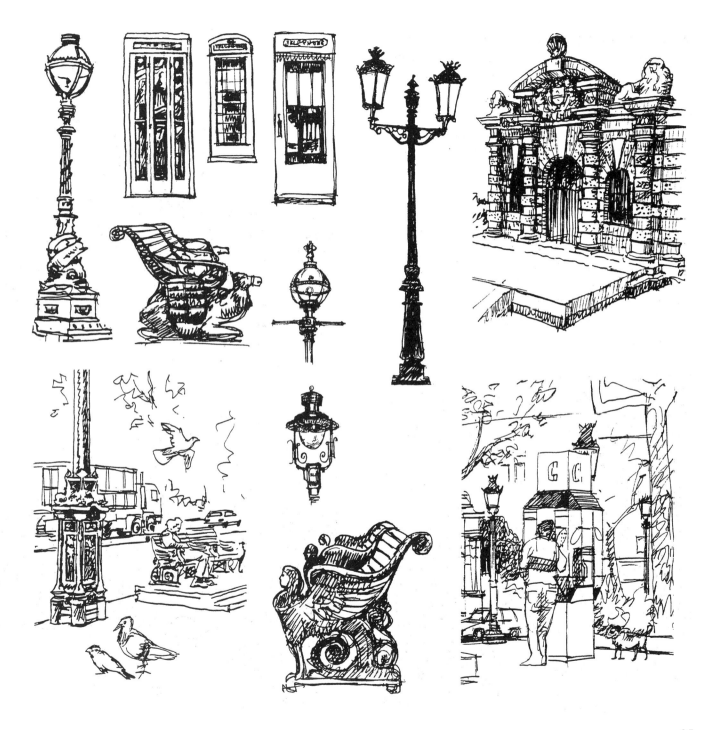

Shopfronts and signage

Shopfronts and facades, some elegant and stately, some garish and tawdry, are everchanging aspects of the urban scene. Wide variation of materials – polished marble walls, plastics, sleek chrome-plated doors or lettering, the fragmented reflections of buildings twisted and distorted across windows – all become highly challenging abstract images to be drawn or photographed. Three-dimensional signs add to this rich vocabulary, as do whole buildings which are painted with eye-catching effects.

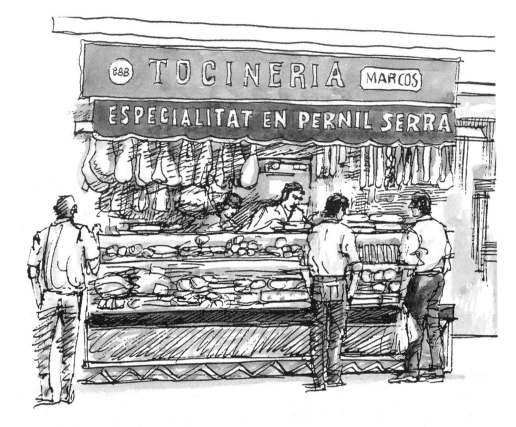

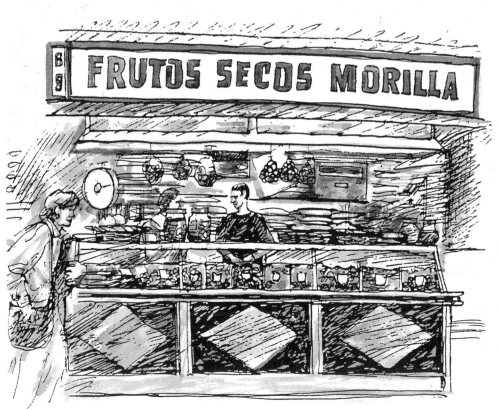

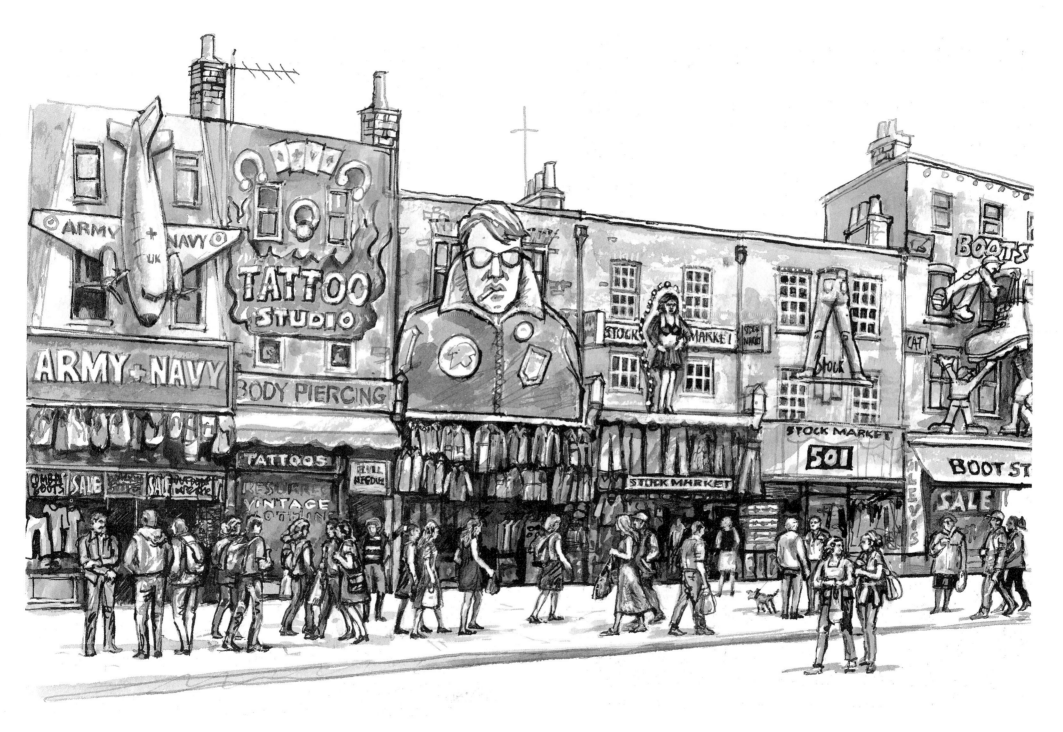

Advertising hoardings, posters, murals, graffiti, all form part of our everyday environment. Sometimes their messages or visual juxtapositions make poetic statements about present day society or lifestyles. They can help to convey a real sense of time and place. Neon at night, reflections on wet pavements, the rich patterns and collage-like accumulations of flyposters can all make exciting subject material for the artist.

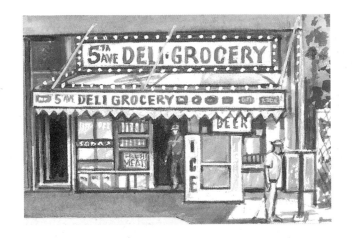

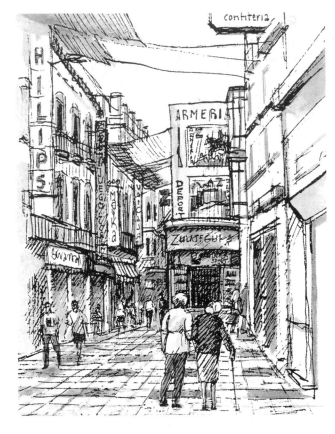

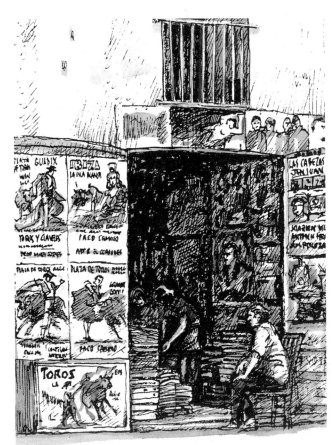

Bookshop · Seville

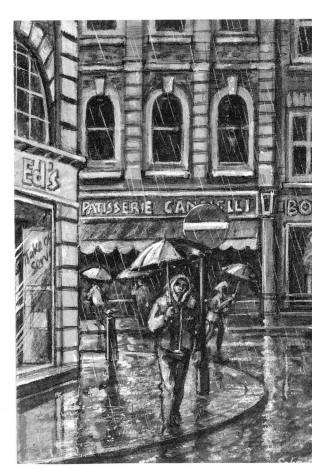

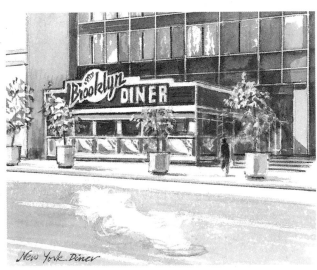

New York Diner

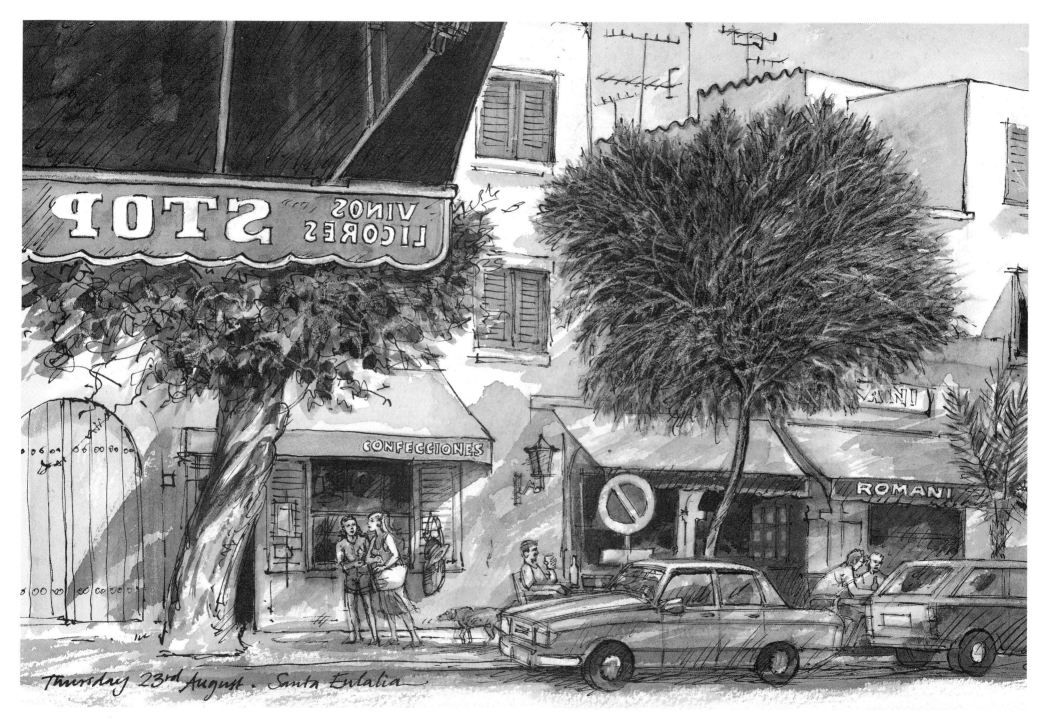

Thursday 23rd August. Santa Eulalia

Transport

Some countries have retained traditional methods of transport and these in turn can be included in sketches to add further interest or authenticity. For example, bicycles are as popular as ever in Amsterdam as are the well-used trams.

I am starting to put in buses, cars, motorbikes and the like in the certain knowledge that in a few years time they will start to look very old fashioned and give my drawings a real period feel.

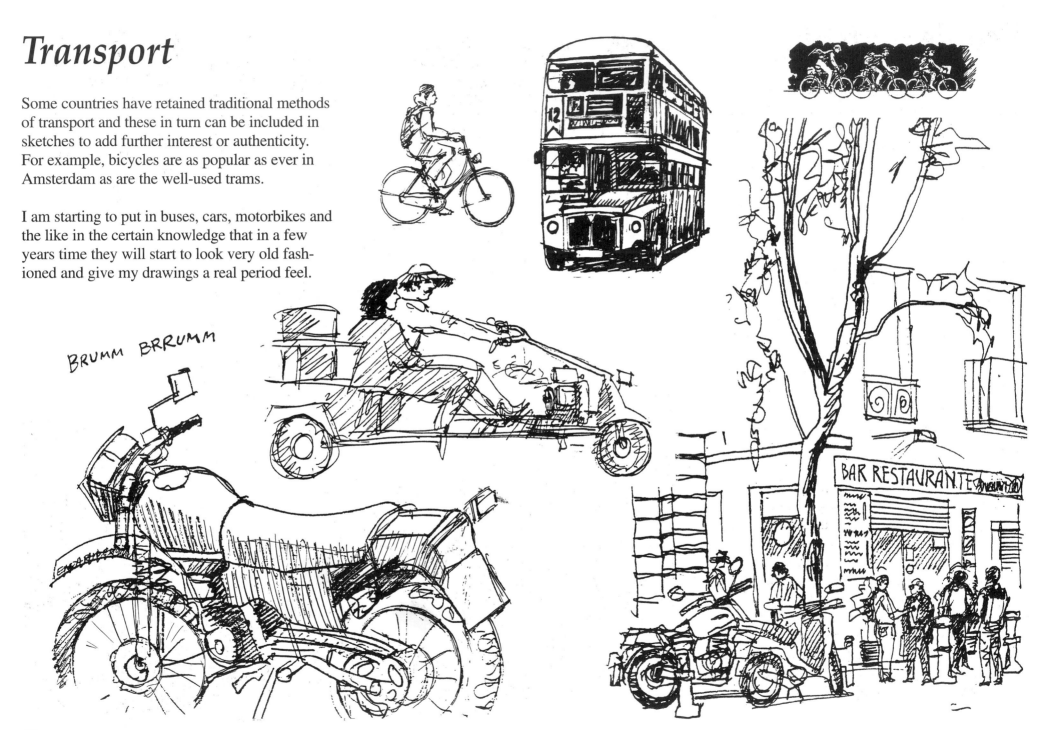

BRUMM BRRUMM

BAR RESTAURANTE

People watching

Nothing is quite as fascinating as watching people but it is far from easy to capture character in a quick sketch. Like a voyeur, I always try to draw without being observed, in case my subjects ask to see my efforts and complain that I haven't done them justice or I have made them look like an unflattering caricature. It's not like taking a snapshot, but speed is of the essence.

Sitting down in a corner with a small book that could pass for a private diary or a postcard, and rationing the number of times you look up at your subject is the best strategy. You have to train your visual memory and retain an after-image in your mind's eye once you look away. Of course they may move. If you are lucky they might resume the same pose but sometimes you're left with just a few precious marks and you have to fill in between, rather like a dot-to-dot puzzle.

This process can be quite exhausting. All I can say is that you get better by doing it and that drawing with tools which assist in making speedy marks is essential. Maybe a pencil to begin with – since you can always draw over the top in ink if you want to. Using a pen directly without any preliminary pencilwork, as in the sketches on the right, will force you into a more precise mode, since erasure is difficult. The search for an edge or a line will result in a quality of movement rather like a multiple exposure, and I feel this can add vitality to a drawing.

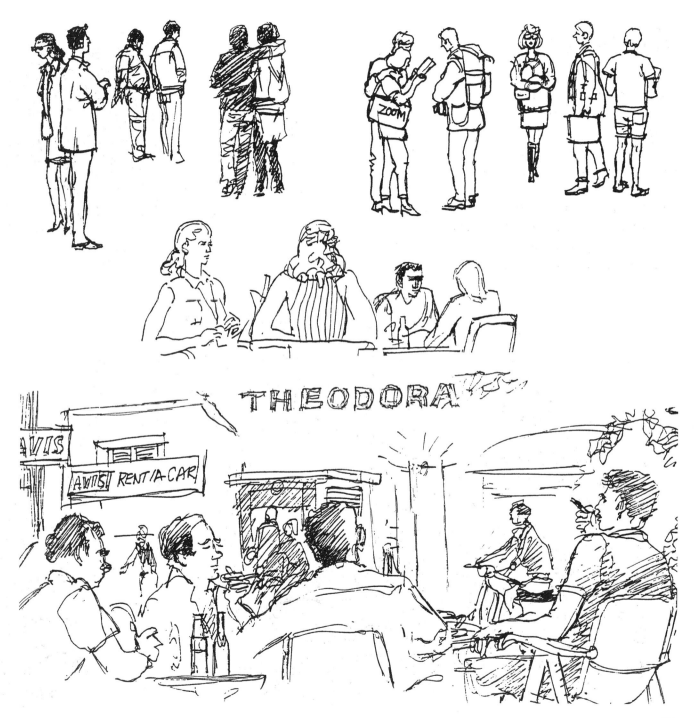

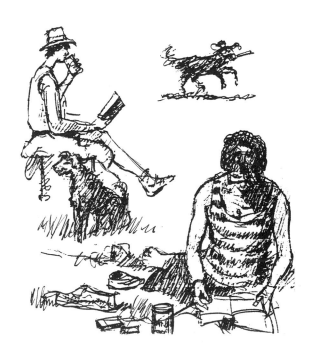

Fashions, clothing and accessories

The inhabitants of modern towns are subject to constantly changing fashions in clothing and accessories. You only have to look at films taken a few years ago to observe how rapidly but almost imperceptibly these changes take place. It is worth recording them in your sketchbooks and noting how much clothing can help to define character, interests and occupations. Even without details we can define general body shapes and gestures in simple silhouette forms.

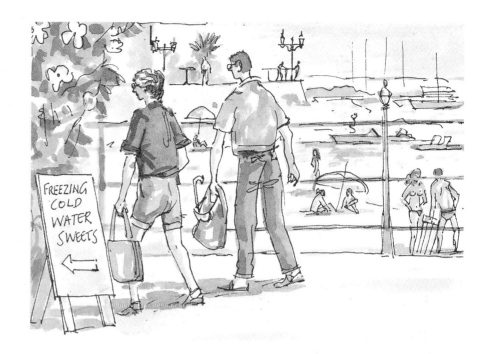

FREEZING COLD WATER SWEETS

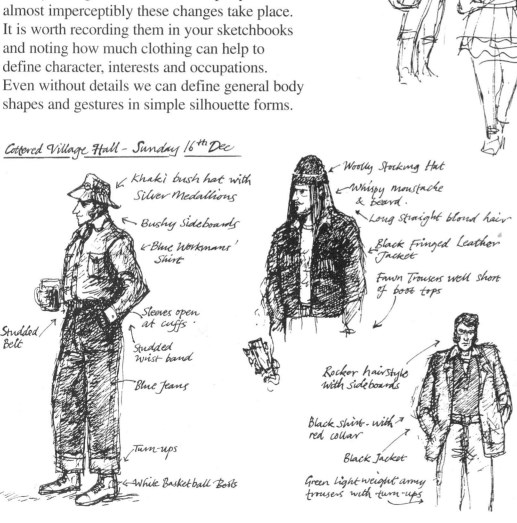

Cottered Village Hall - Sunday 16th Dec

Khaki bush hat with Silver Medallions

Bushy Sideboards

Blue Workmans' Shirt

Studded Belt

Sleeves open at cuffs

Studded waist band

Blue Jeans

Turn-ups

White Basketball Boots

Woolly Stocking Hat

Whispy moustache & beard

Long straight blond hair

Black Fringed Leather Jacket

Fawn Trousers well short of boot tops

Rocker hairstyle with sideboards

Black shirt with red collar

Black Jacket

Green light-weight army trousers with turn-ups

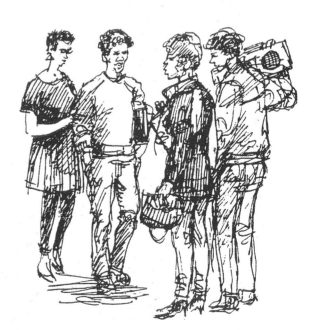

Travelling with a sketchbook

Sketching as you travel is tremendous fun, very satisfying and a good challenge, since you tend to have to record everything very quickly. However, the subjects of your sketches may not find such enjoyment – they can be curious or resentful, so try to be inconspicuous.

Here are a couple of hints. Keep your equipment to a minimum – things that can fit into a pocket or small bag. Perhaps pretend to be doing something else – I often make out that I am writing postcards.

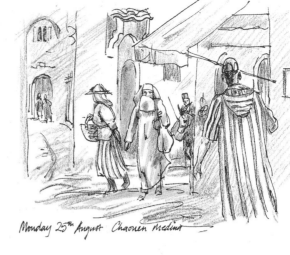

Despite the heat many people are wrapped up in heavy woollen jellabah with hoods over their heads

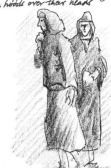

Monday 25th August Chaouen Medina

Berber women wear several heavy layers of clothes including 'long johns'

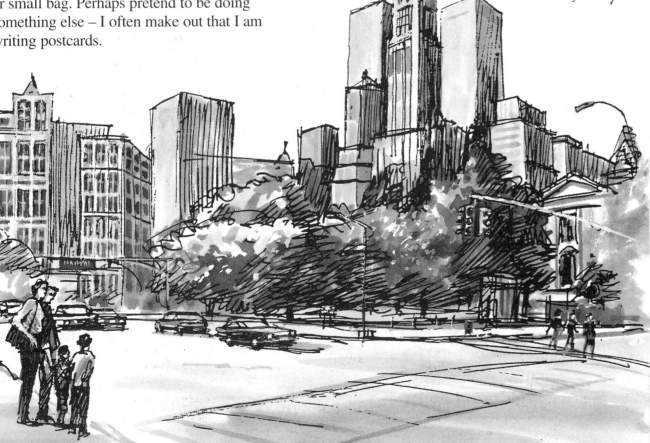

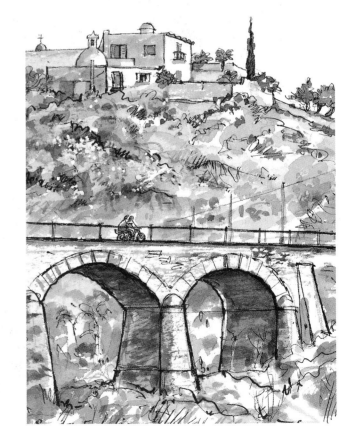

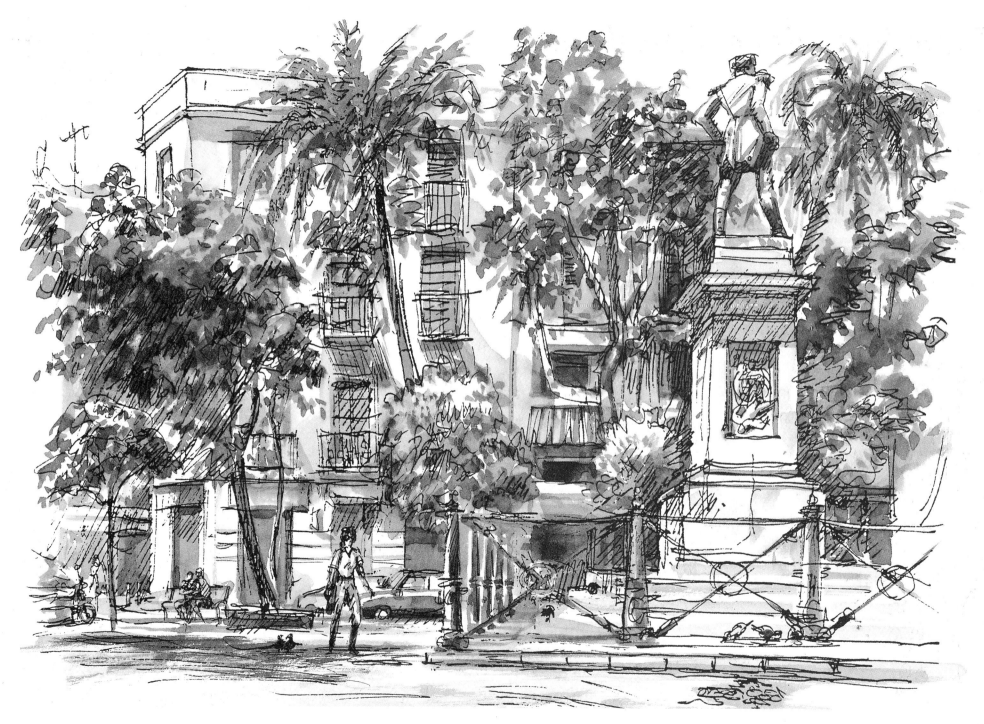

Seasons

Autumn, winter, spring and summer – sometimes it is a positive joy to be working outside; other times this quite plainly is not the case. In the past, I have sketched through a car windscreen as the rain pours or snow falls outside. Keep a camera handy in these instances to capture fleeting effects.

The winter months are a good time to see the landscape stripped bare or simplified by snow. Trees in full leaf frequently obscure interesting architectural details so it is a good time to observe them clearly through the bare branches.

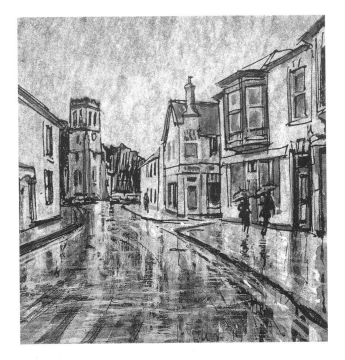

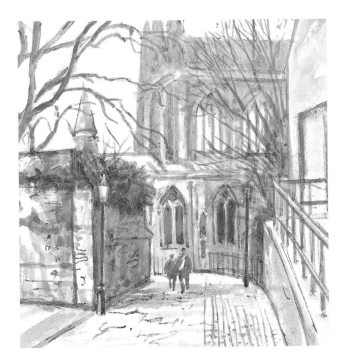

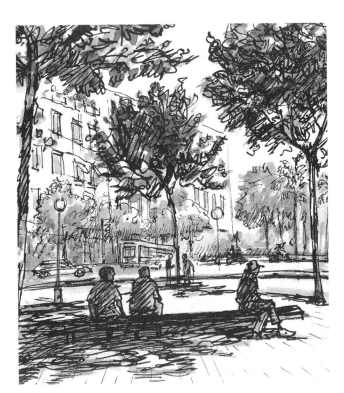

Summer months are good for drawing people at leisure, or strong contrasts of lighting and deep shadow.

Autumn in Britain can usually be relied on to provide some wonderfully misty mornings, perfect for sketching simplified atmospheric perspectives.

Reflections on wet roads or pavements can totally transform a scene and present quite magical subject matter.

Experiments with a variety of media, as in the sketches featured on these pages, will prove their suitability for certain conditions.

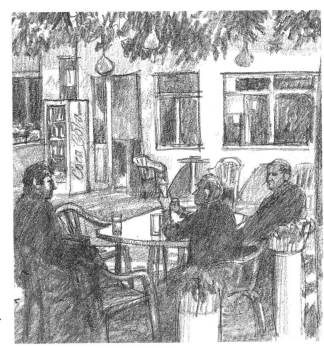

Times of day

Apart from climatic changes, the times of day present the artist with a lot of variety and subject matter. Early risers see quiet streets with the milkmen and newspaper deliverers, market traders setting up, joggers, even urban foxes going about their business. Then come commuters heading for the stations, parents taking kids to school, the dog walkers, shoppers and the normal hustle and bustle of town life.

In hot climates you get the midday siesta when people shelter from the sun and only mad dogs and obsessive sketchers go out (sensibly wearing appropriate protection) in search of some visually exciting inspiration.

Twilight or moonlight provide elusive qualities where shapes appear simplified and details disappear. James Whistler captured some of these effects in his 'nocturnes' and wonderful etchings of the river Thames in London.

When it comes to night scenes the American painter Edward Hopper portrayed the city's commonest sights – store windows and lunch counters as an oasis of light in the darkened streets, with people depicted like actors on a stage. Many of his oil paintings were thoroughly planned in a series of on-the-spot tonal crayon sketches, before he put a brush to canvas. For some complex paintings he did as many as thirty or forty such sketches including studies of architectural details and figures.

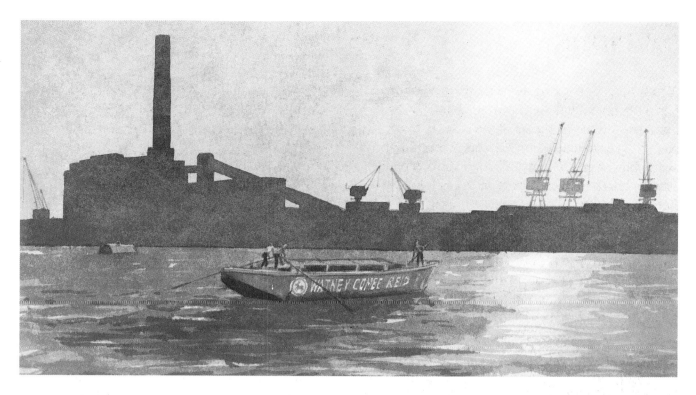

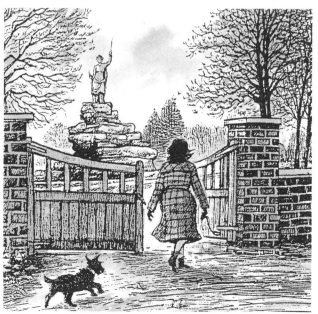

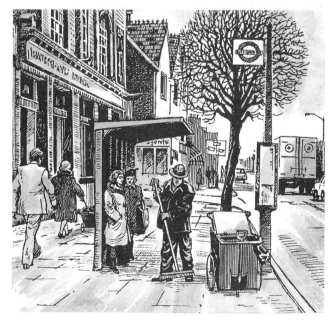

Light and its effects

The effects of light upon the landscape change throughout the day. At times the light can emphasize particular features of a scene while at other times it can throw the same features into obscurity. These changes can be fleeting and can have a dramatic effect upon the scene, perhaps changing the mood radically. If you are lucky you can return at the same time of day and experience similar conditions, but if this doesn't work, a camera is the only way to capture the mood. However, there are times when only our visual memory or imagination are the ways to fill the gaps.

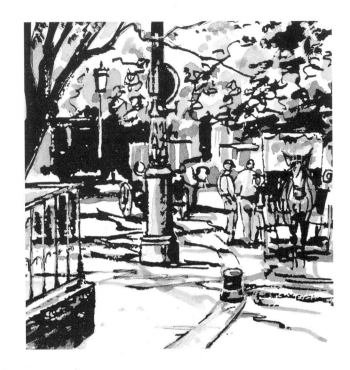

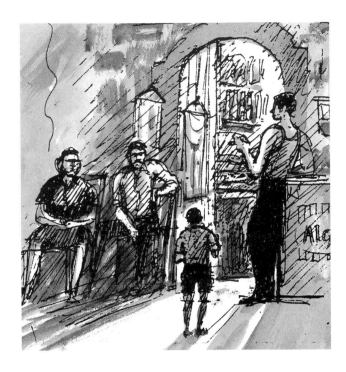

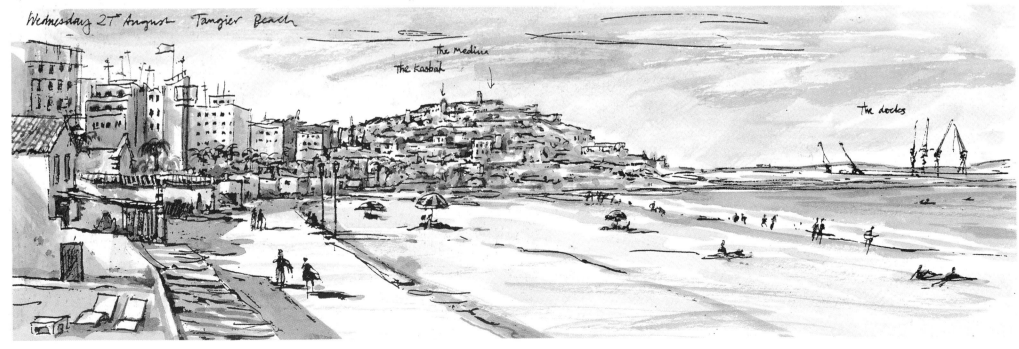

Wednesday 27th August Tangier Beach

The Medina

The Kasbah

The docks

Sketching in haste

There is a limit to the amount of detail and information one can include when sketching in a hurry. While this may be a disadvantage at times, it certainly sharpens one's visual shorthand and can produce work which displays great energy and excitement.

To train the hand and eye to sum up essentials, set yourself a time limit per sketch and be sure to move on to a different project.

These sketches were done whilst standing up, using a fibre-tipped pen without any preliminary pencil drawing.

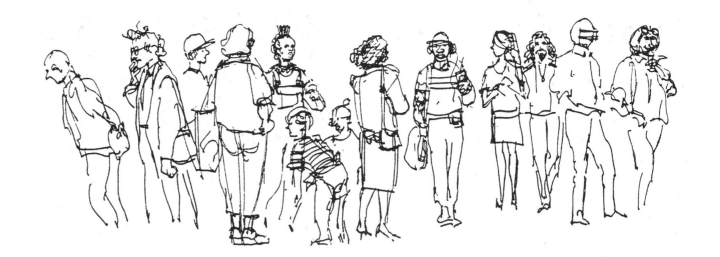

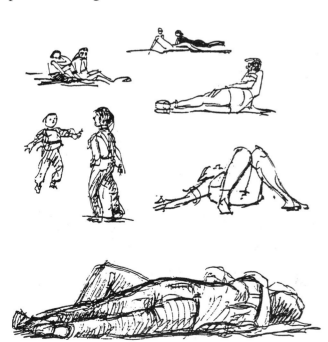

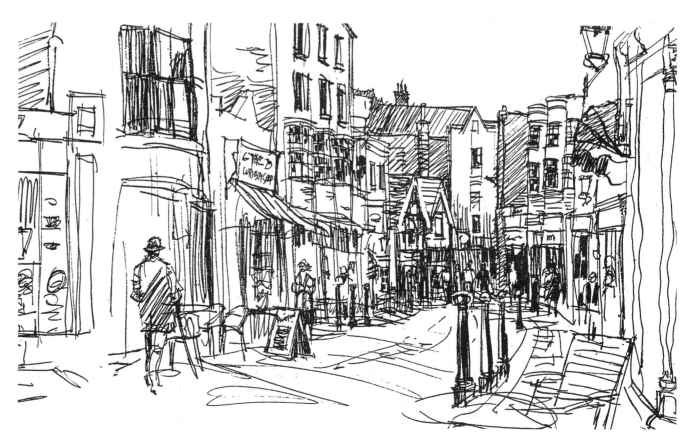

Use of the camera

As we sit and sketch, we are focusing on visual qualities; this can broaden our perceptions so that the whole act becomes a unique, memorable experience. If, for whatever reasons, we have to leave the work unfinished, to continue or develop it elsewhere, a photograph is a good way of recording the information.

If you were sketching a very broad vista which won't fit onto one photograph, take several and stick them together as a panorama or compilation. Try to use your own photos since they represent your own viewpoint, perception and motivation, not those of anyone else.

Close-ups of details or transitory moving elements can all be brought together in a composition. The example shown on this page was compiled from photographs taken during a boat trip down the river Thames.

I have not slavishly copied any particular image but have juggled parts about, altered sizes and left things out. (A more finished sketch from this material appears at the top of page 37.)

There is a value in compiling your own system of reference photographs or magazine cuttings with inspirational images.

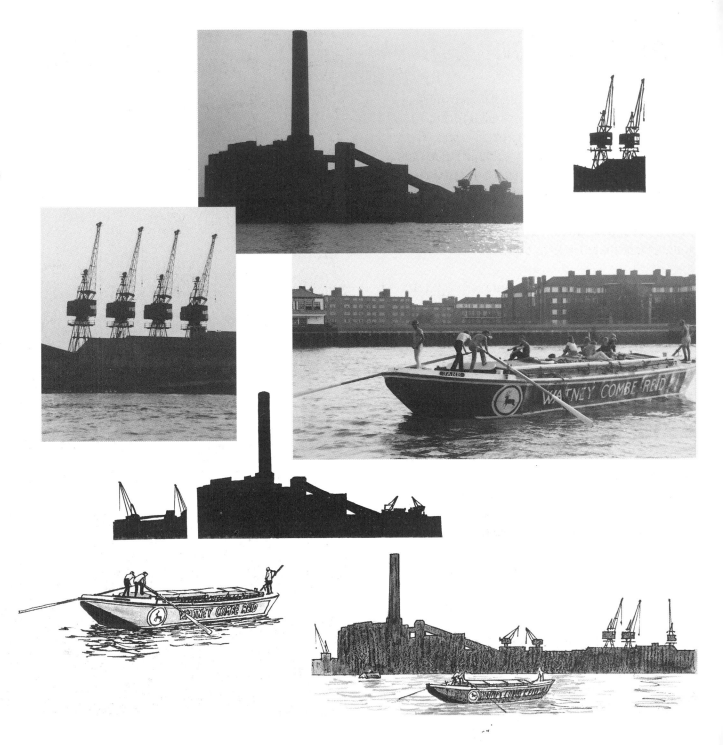

Composition

Sketching can be an end in itself or a means of training hand and eye; it can also form a preparation for a composed picture – part of an overall plan to design and organize elements within a defined space. We may use images from a variety of sources – sketchbooks, photographs or magazine cuttings. Basically, images which remind us a of a mood, memory or association rather than images just to copy.

An illustrator working on a commission rarely, if ever, finds subject matter ready-made and has to undertake preliminary studies or show rough visuals to a client before progressing with the finished artwork.

Such preliminary procedures enable alternatives to be evaluated and structures for holding pictorial elements together to be explored. At this stage it is best not to get involved with details. Objects can for the most part be indicated as simple shapes and it becomes a game of fitting them together like a jigsaw pattern. The result should be one of order as averse to confusion.

The sketches on this page show how various alternatives were explored on a small scale to arrive at a more satisfactory arrangement.

The two little girls to the right of the picture were turned round to face inwards and lead the eye to the centre of interest.

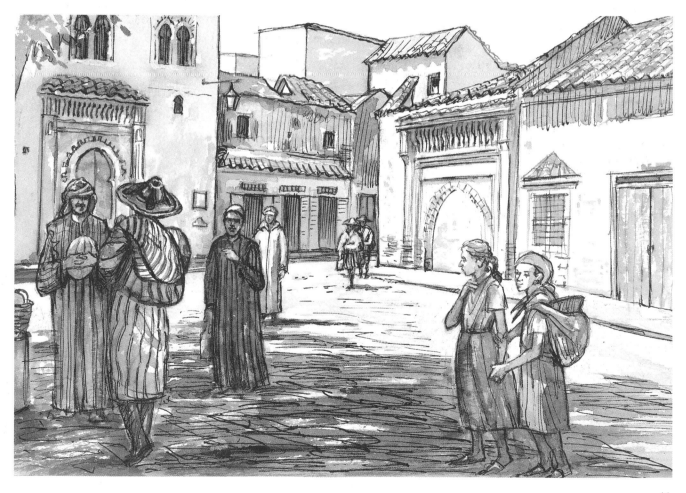

When composing a picture we manipulate elements within a design area, adjusting the viewpoint, moving something or even leaving it out. Here are some useful principles.

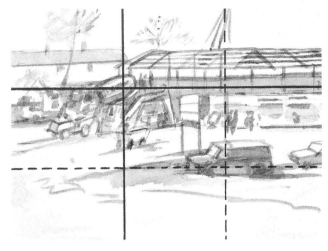

There is a 'rule of thirds' in every composition, by which imaginary lines divide the picture area into thirds both horizontally and vertically. Strong elements can coincide with these.

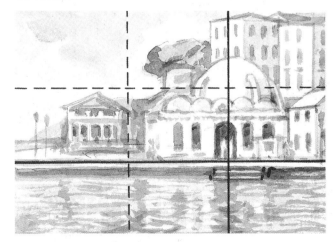

It is well worth making simple thumbnail sketches and exploring and adjusting the arrangement of major forms before starting the final picture.

Simple implied geometrical shapes such as triangles or circles are often the base of a composition. The diagram on the right is based on triangles – look at the basic underlying structure and how key elements are tied to it.

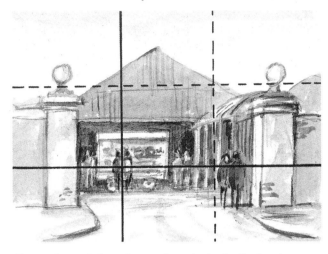

Every picture is based upon the principal of balancing overlapping areas, forms and contours. We define these by drawing them as lines, and so linear arrangement becomes our first consideration.

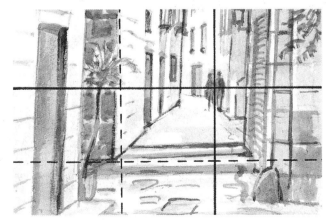

A main focal point is essential. The eye should be drawn to it by the lines in the picture and lines should cross at the main point of interest.

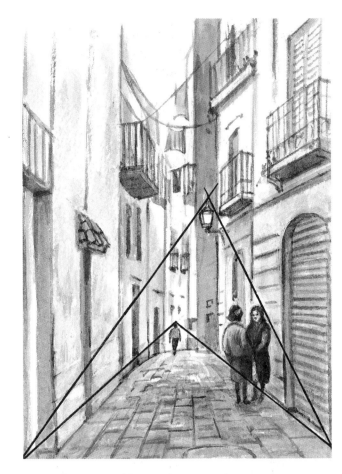

It can be a very instructive exercise to secure some tracing paper over reproductions or postcards of famous paintings to trace out their basic underlying structures.

The eye should be able to follow a natural path in every good picture, and you can make this happen by clever use of line.

Lead the eye in, give it some interest and then let it pass out of the composition. It should be a pleasing path, free of obstruction or decision. Bring the eye in at the bottom and take it out at the top rather than at the sides. Lines leading out of the subject should be stopped by some device or another line leading back to the focal point.

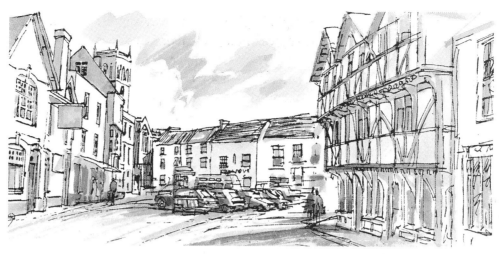

In the first thumbnail sketch, left, the cars in the centre don't seem sufficiently interesting as the focal point of the composition.

In the final composition, below, a couple of seated figures add human interest. The timber-framed building on the right helps redirect the eye back towards the centre of interest.

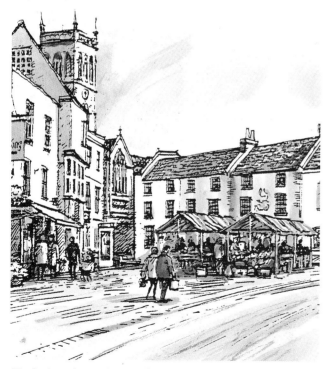

Exploring alternatives with market stalls and shoppers.

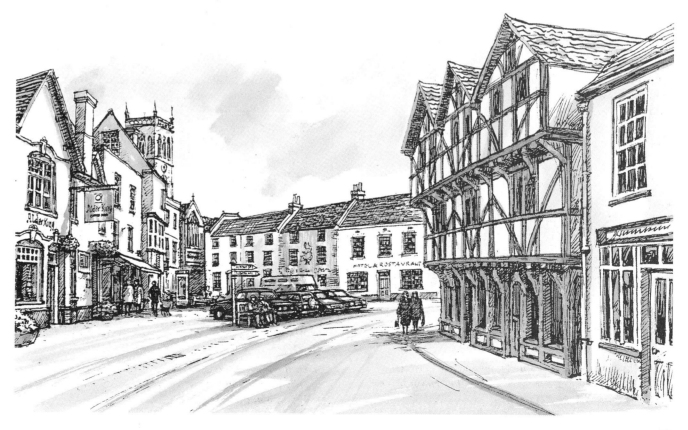

Locating figures

People add interest to paintings, providing a sort of empathy that enables us in some way to enter the picture. This fact grants a certain power to any figures included.

All the elements of a good composition should fit well together. Take a look at the work of many past and contemporary painters and you can see how much attention has gone into their composition. A good way of studying this is to lay a piece of tracing paper over a postcard or reproduction, and then trace the major subdivisions and lines of sight which the artist has used. You will see how carefully and effectively he or she has placed each figure, animal, group or object.

This does not mean to say that figures should be sharply defined; often a strategically placed blob of paint, a shape or flick of colour will suffice. This is most appropriate when the rest of the painting is equally simplified.

However, with more detailed paintings other factors, such as perspective, gesture and shape, must be considered. It must be apparent what the figures are doing, what clothes they are wearing, how old they are, if they are male or female, what their relationship is to each other. This is when keeping, and constantly using, a sketchbook is particularly vital since many of these details are hard to record without practised observation and experience.

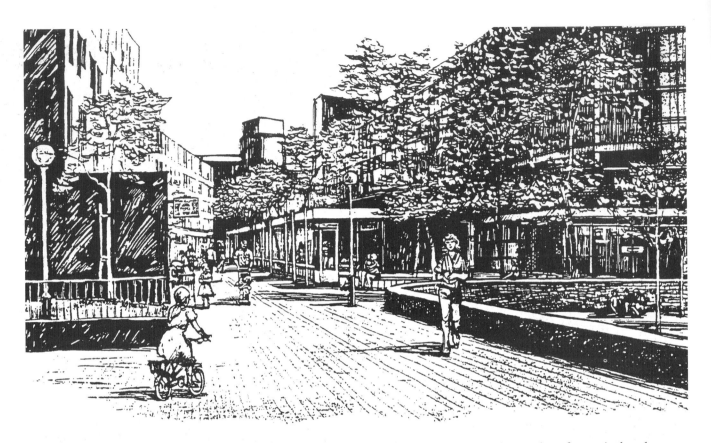

The above illustration was for a magazine and had to include certain elements to create an impression of a particular place.

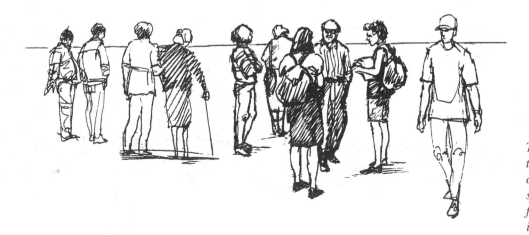

To get your figures to hang on the horizon line, make the line cut through the figures in the same place. Notice how some figures have been incorporated in the composition opposite.

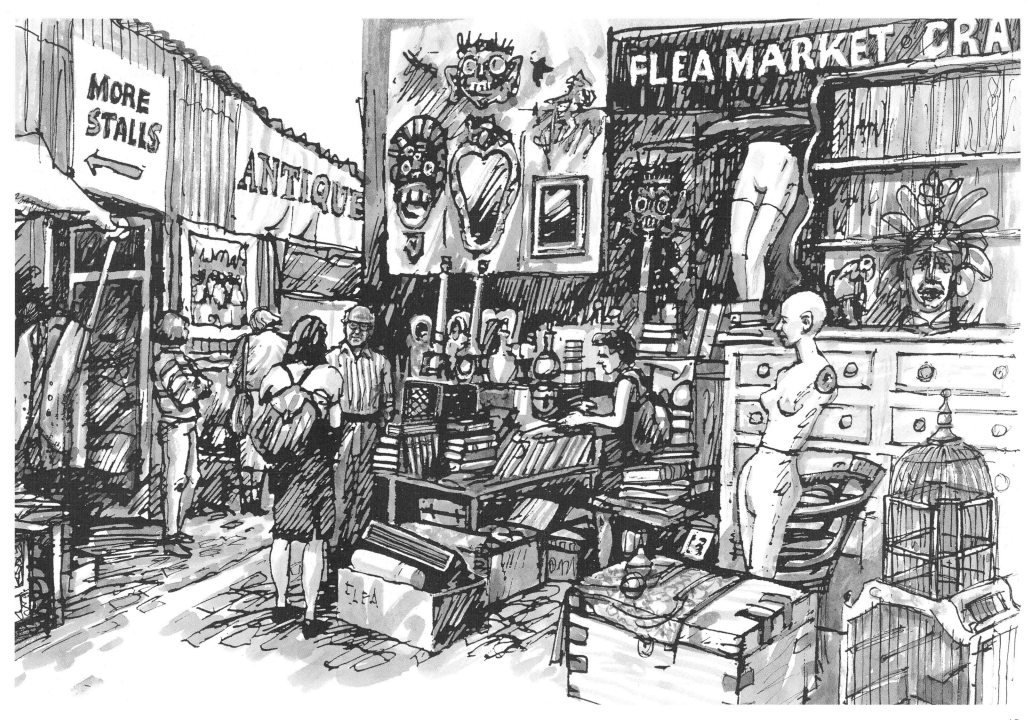

Building a composition

This final example demonstrates a compilation from sketches and photographs being brought together in a pictorial composition.

You can write on your sketches to remind yourself of important features or make notes about the possible use of colour, perhaps.

The sketches on this page are my thumbnail layouts of human interest for the final composition on page 47.

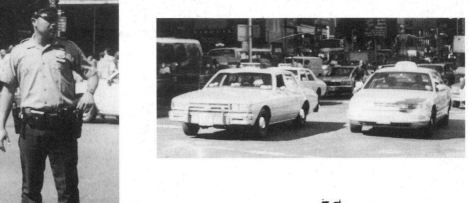

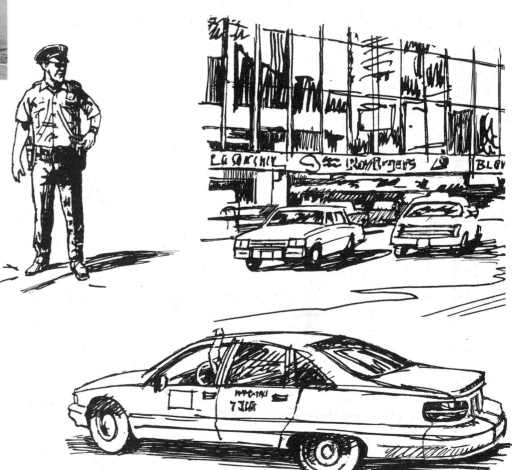

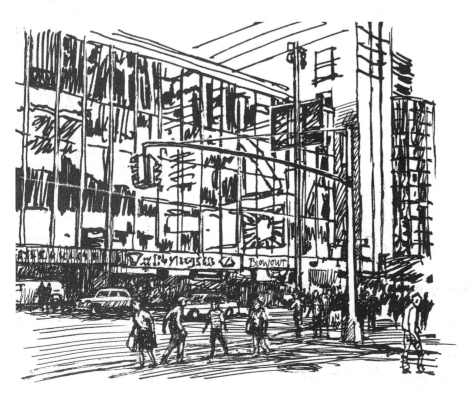

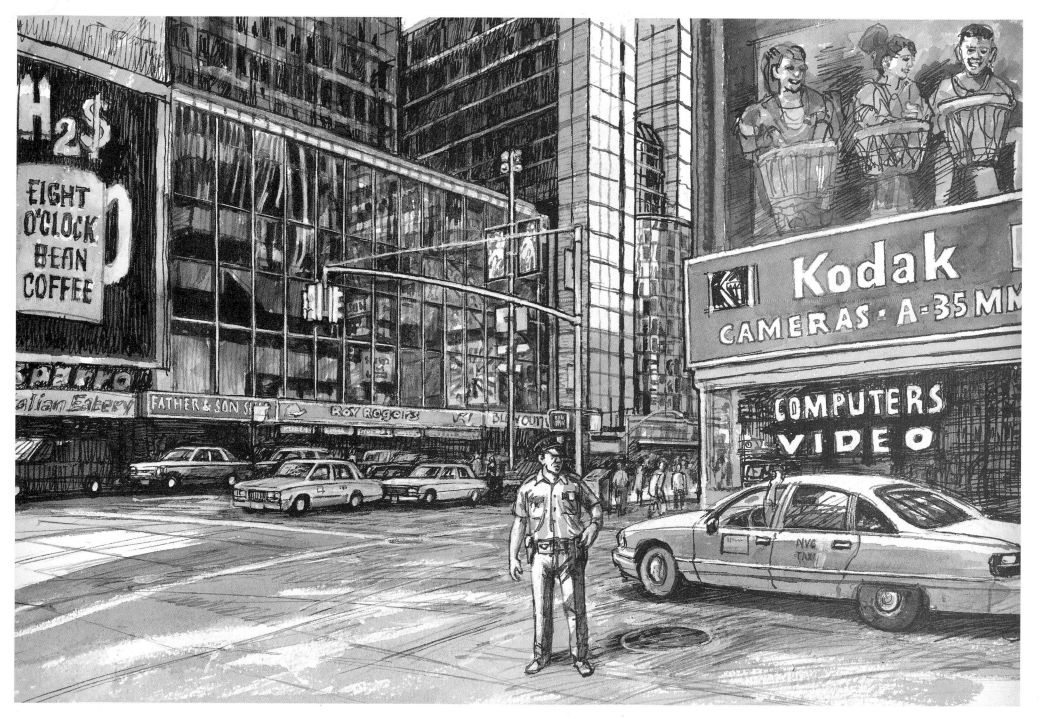

Conclusion

I hope that having read this book you are encouraged to go out and buy some basic materials and get sketching. You will soon find out what a tremendous pleasure it is. There is no need to be daunted, especially if you remember the following points.

• Consider your sketchbooks to be private and personal, your way of expressing yourself without inhibition.

• It is cheap and easy to get equipped for sketching.

• Sketchbooks can be big or small; choose either to suit your personality.

• The best subject matter can be very close to home so you needn't necessarily search far afield.

• Keep trying and you will soon get to grips with perspective.

• Start off with simple tones and shapes and then move on to details.

• Practise sketching at speed since it hones your visual shorthand skills.

• What you put in your sketchbook when you are travelling will be a permanent and personal reminder of your experiences.

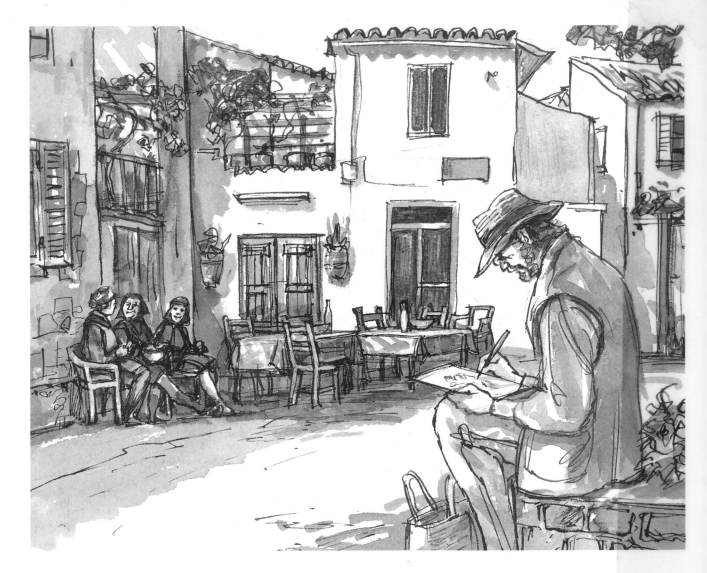

• Use your sketchbook as a reference book containing your draft sketches, thumbnail layouts and trial compositions.

• Remember to lead the eye to a major focal point and to include people so that the viewer is able to empathize with the picture.

• As well as your sketches, a variety of other visual sources can be useful in compiling a picture. Try making a collection of photographs, postcards and written notes on colour which can later be brought into play in a studio situation.